PACIFIC NORTHWEST
NATURE

PACIFIC NORTHWEST
NATURE

Coloring for Calm and Mindful Observation

LIDA ENCHE

SKIPSTONE

Published by Skipstone, an imprint of Mountaineers Books
Printed in Canada
20 19 18 17 1 2 3 4 5

Design: Jen Grable
Cover illustrations: Lida Enche
All illustrations by the author

♻ Printed on recycled paper

ISBN (paperback): 978-1-68051-092-8

Skipstone books may be purchased for corporate, educational, or other promotional sales, and our authors are available for a wide range of events. For information on special discounts or booking an author, contact our customer service at 800-553-4453 or mbooks@mountaineersbooks.org.

Skipstone
1001 SW Klickitat Way
Suite 201
Seattle, Washington 98134
206.223.6303
www.skipstonebooks.org
www.mountaineersbooks.org

LIVE LIFE. MAKE RIPPLES.

MIX
Paper from
responsible sources
FSC® C103567

ARTIST'S STATEMENT

I grew up in a place that was as flat as a pancake; if we wanted to see something different, we had to get in the car and drive for hours. Believe it or not, we thought of the overpasses that crisscrossed the highway as exciting "hills"! I feel so lucky to now live in the Pacific Northwest, a region with an incredible amount of geological, plant, and animal diversity. From rainforest banana slugs to desert cacti to high alpine mountain trails to craggy windswept beaches and, oh! Don't forget the volcanoes! We have got it all.

I was delighted when I was presented with the opportunity to illustrate this coloring book about the Pacific Northwest's natural beauty. While I was creating the drawings that you see here, I found myself feeling as though I had entered the world that I was drawing. I could smell and feel the salt air breezes, hear the grasses blowing in the wind, and witness shooting stars blazing across clear night skies. When you color in this book, my wish is that you can use your mind's eye to escape to some of the natural wonders presented here.

Thank you for allowing my illustrations to keep you company and perhaps transport you to another place where peace, happiness, and natural beauty surround you. Happy coloring!

ACKNOWLEDGMENTS

Special thanks to my loving family for supporting me in my dream to illustrate this coloring book. Also, thank you to my students for being my cheerleaders and also excellent editors!

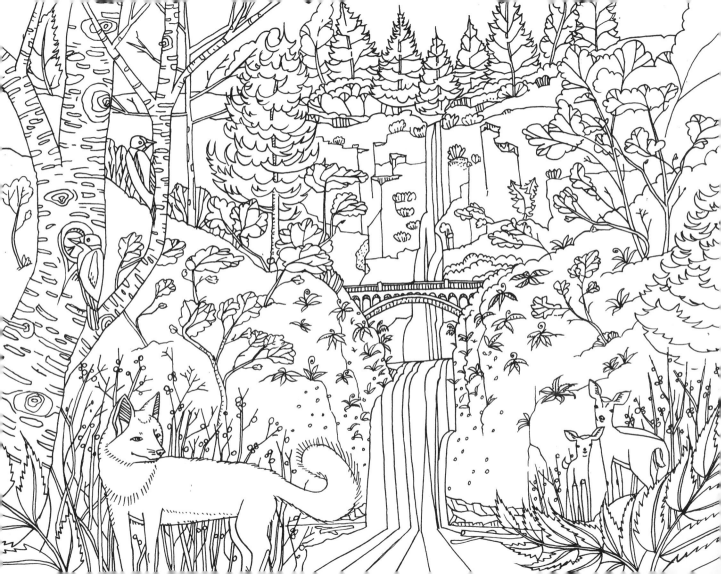

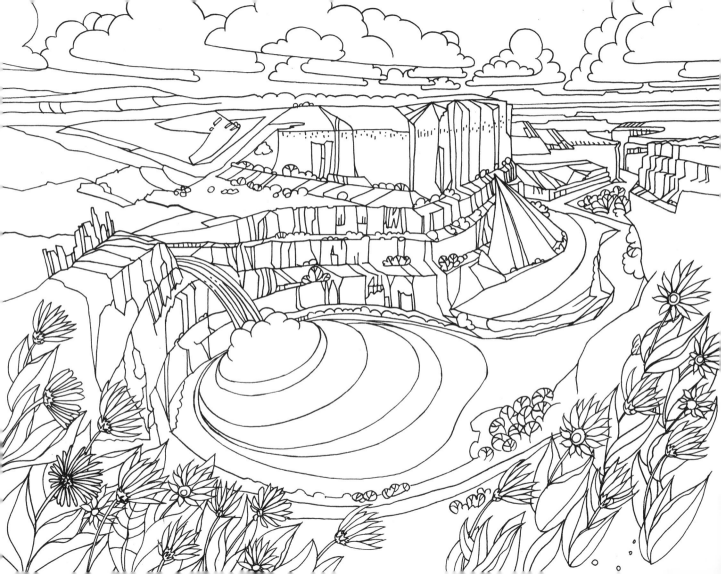

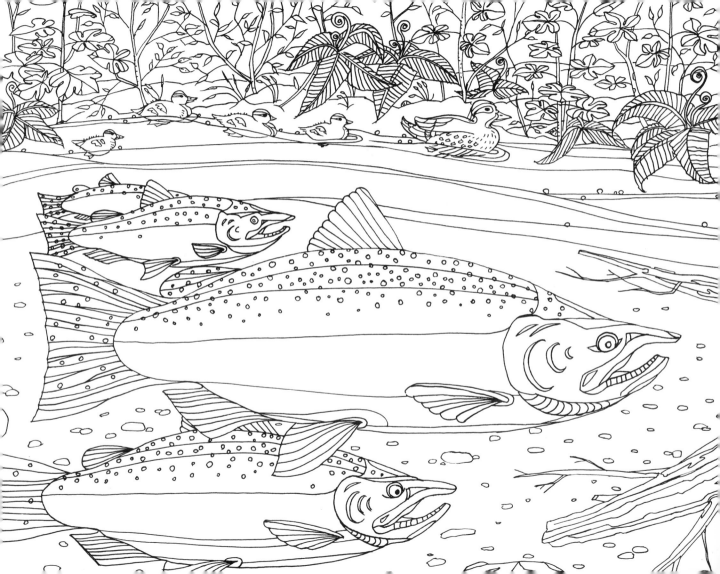

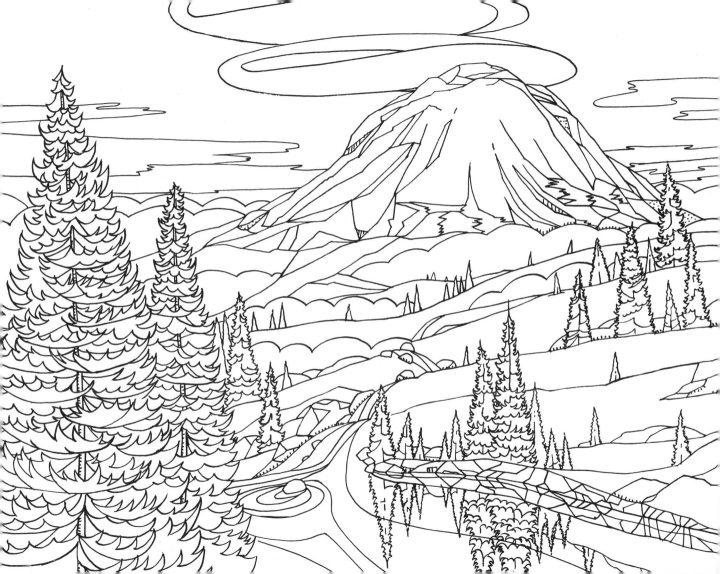

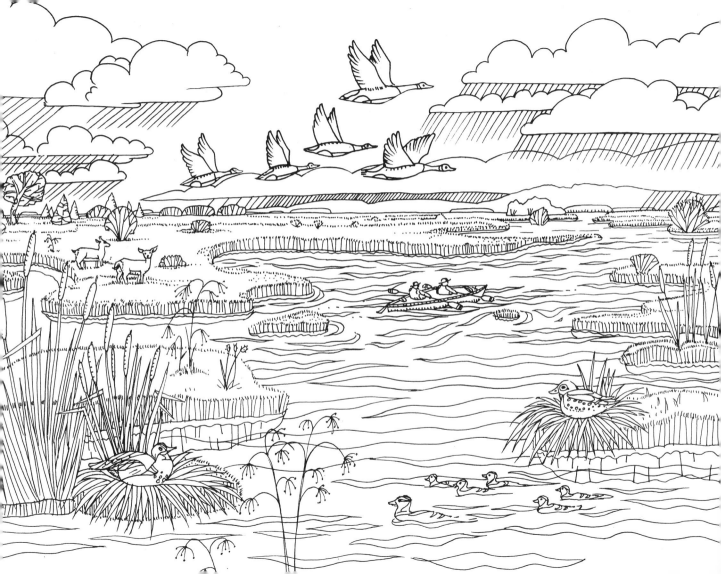

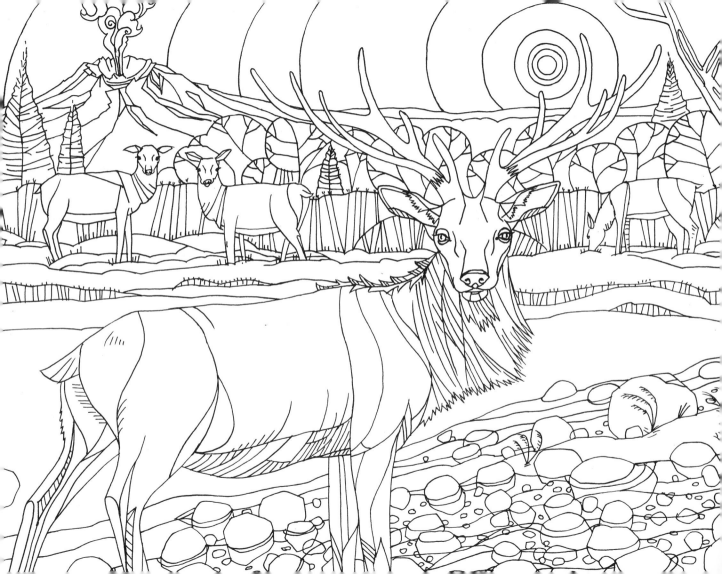

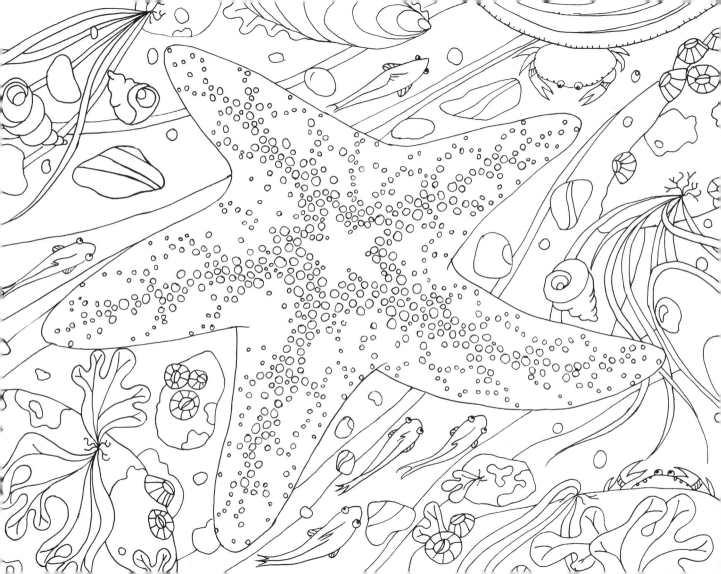

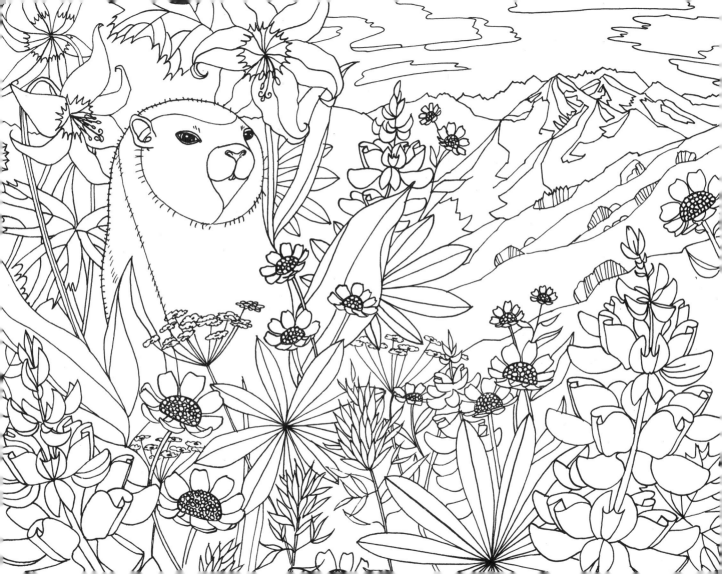

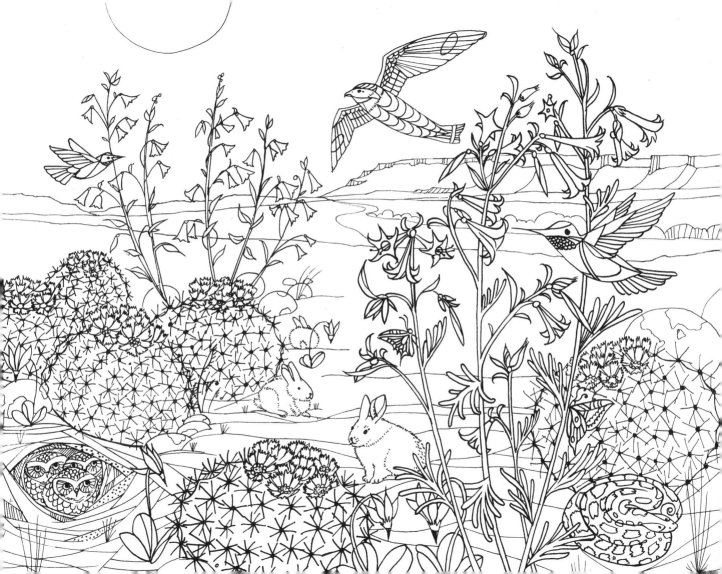

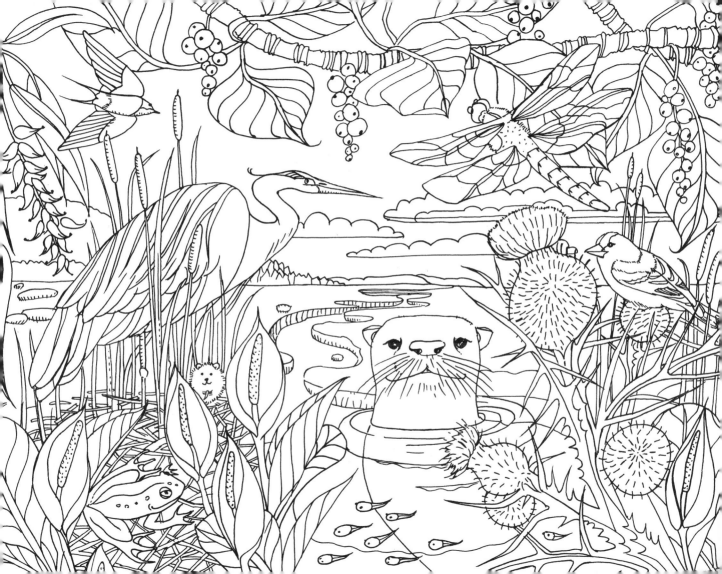

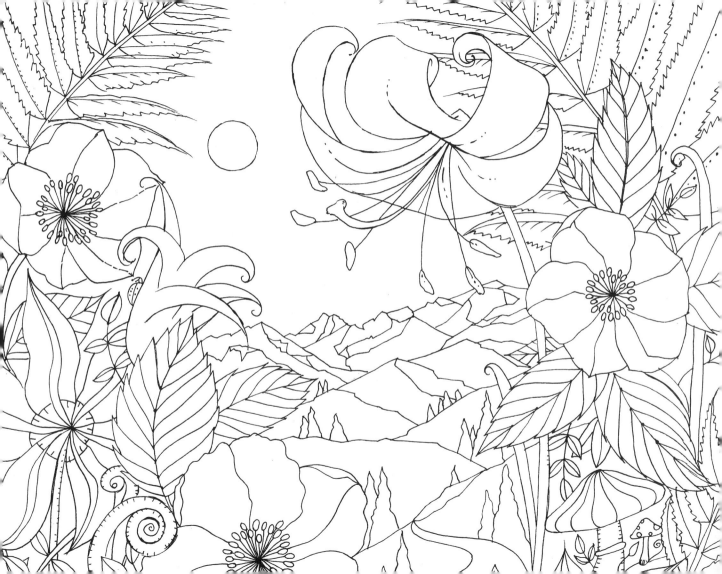

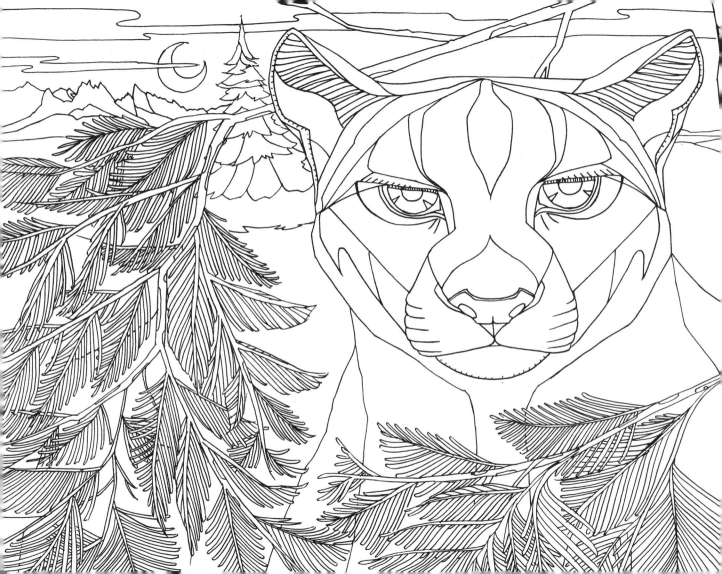

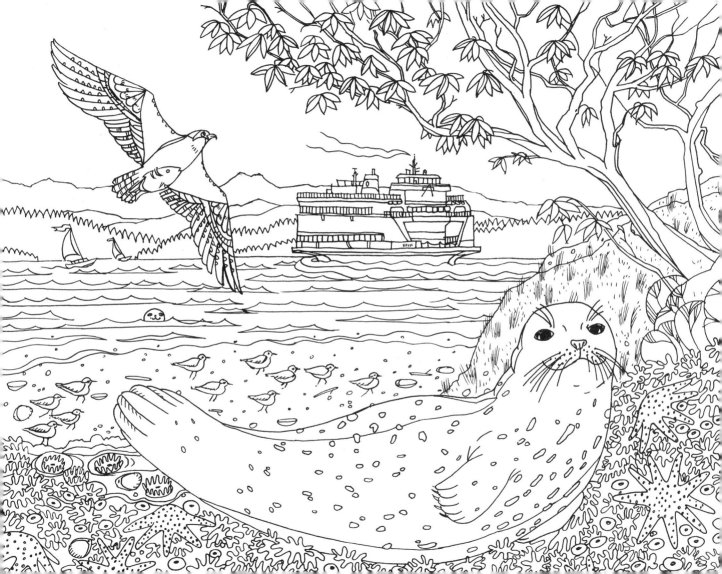

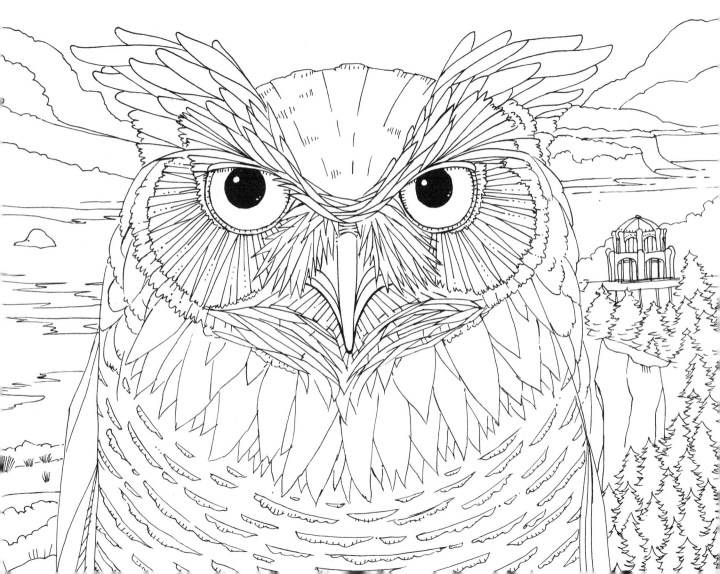

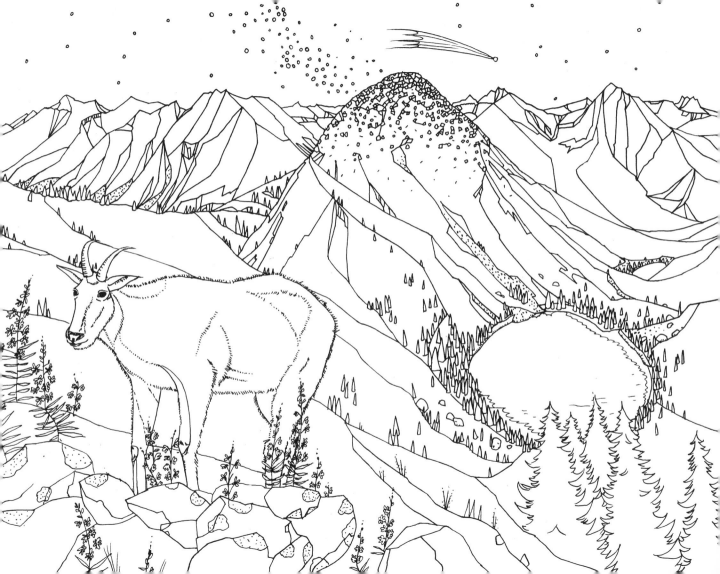

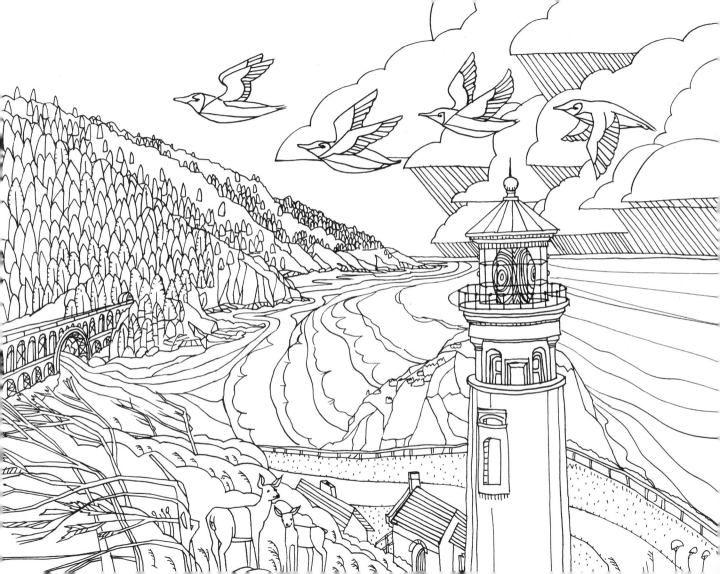

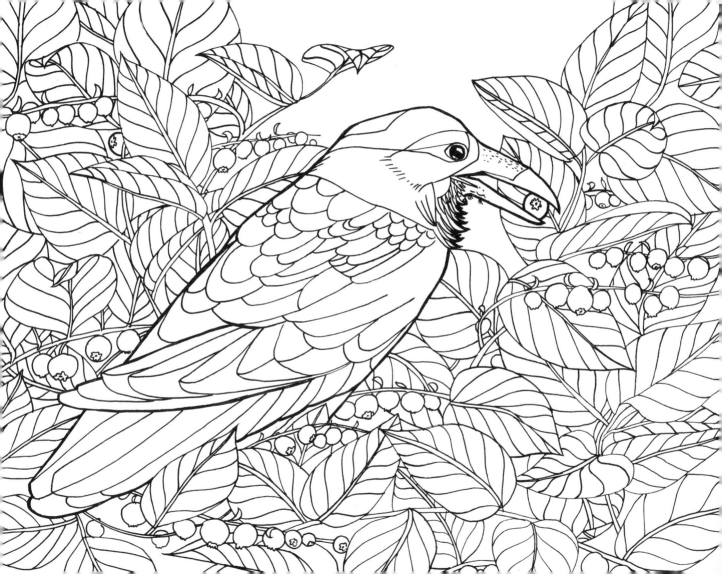

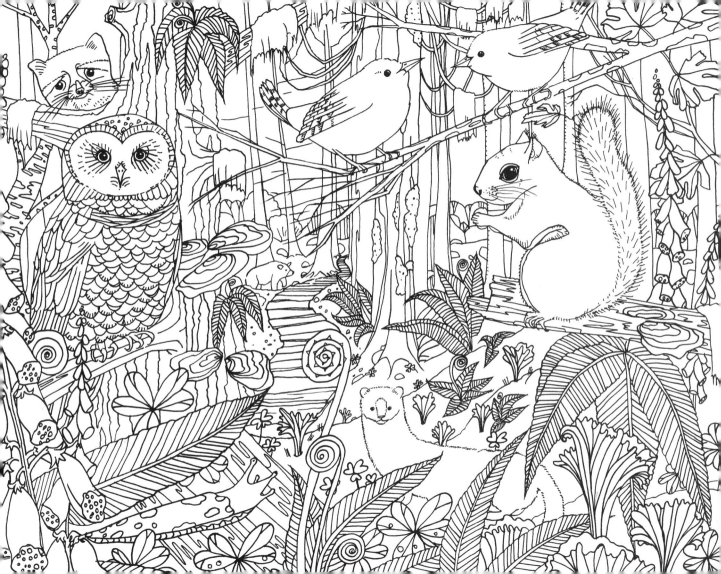

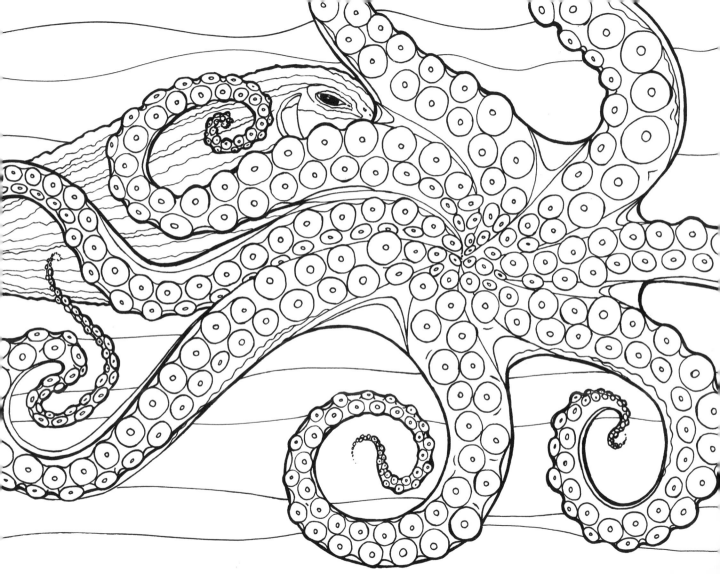

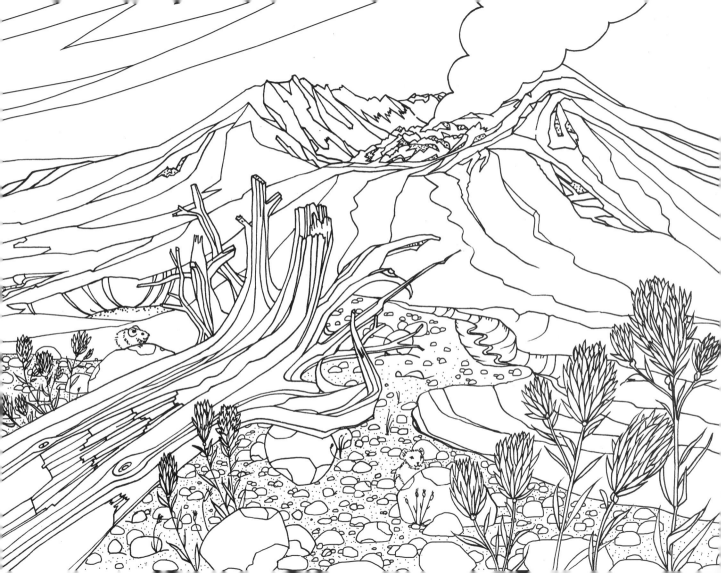

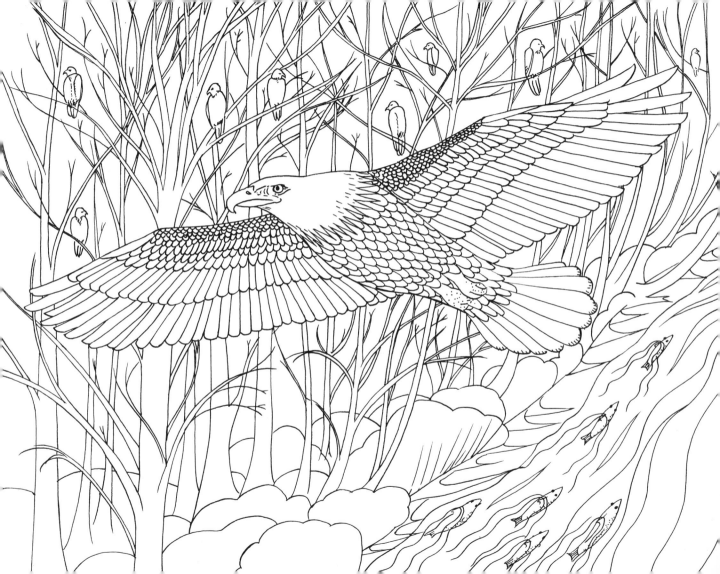

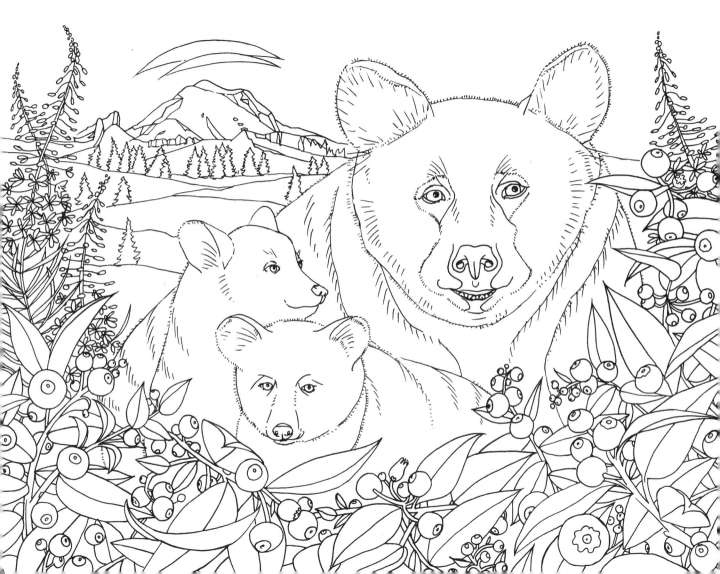

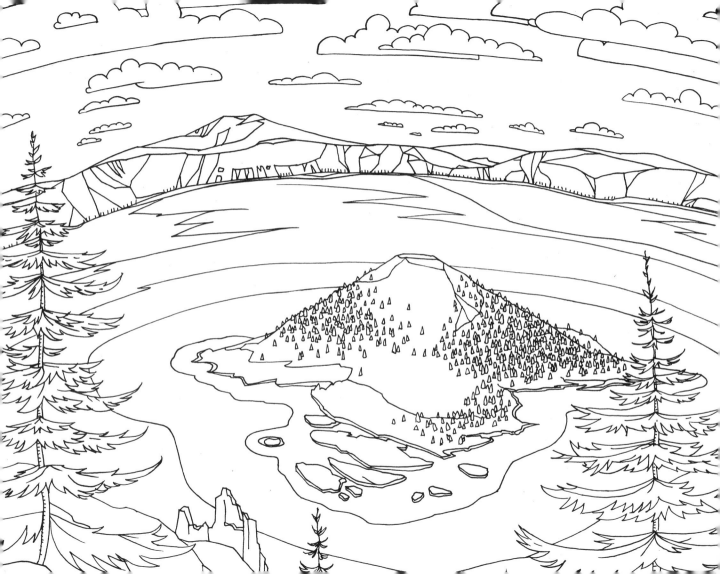

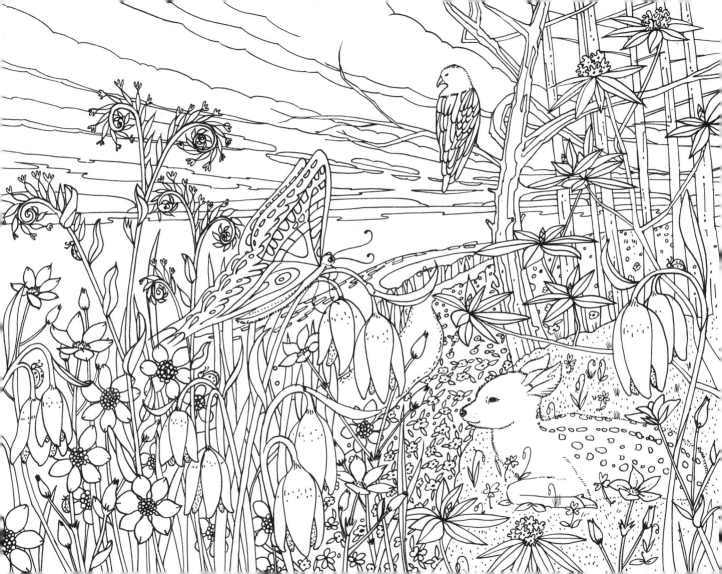

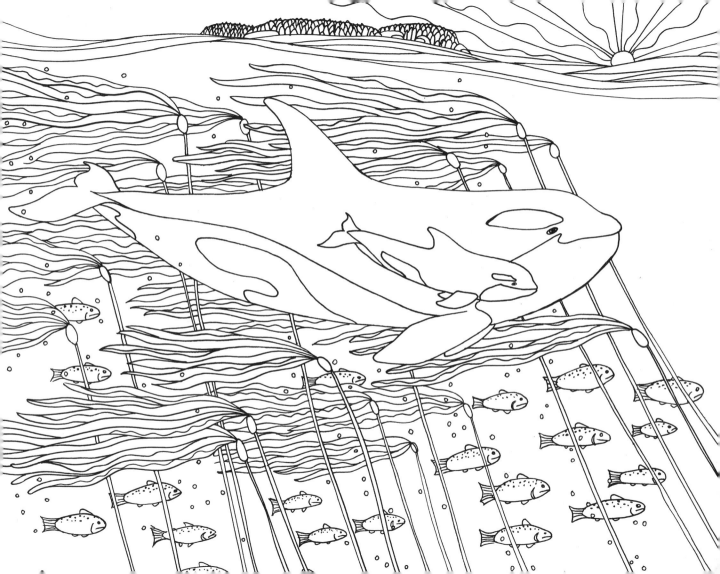

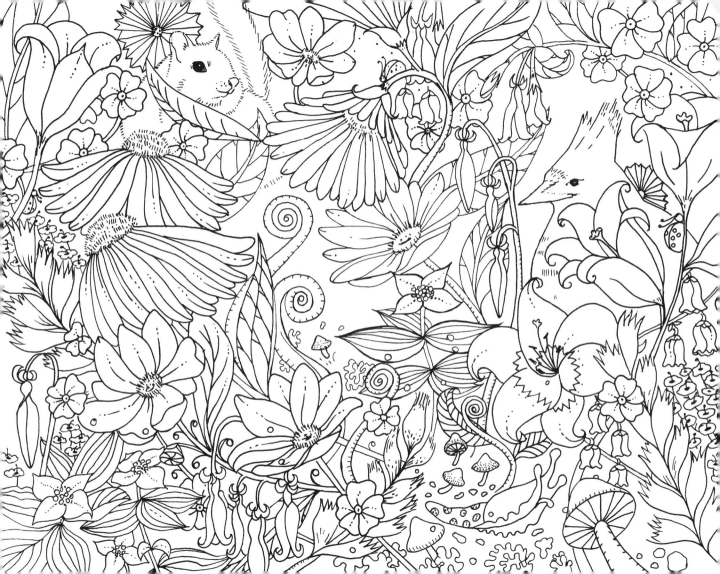

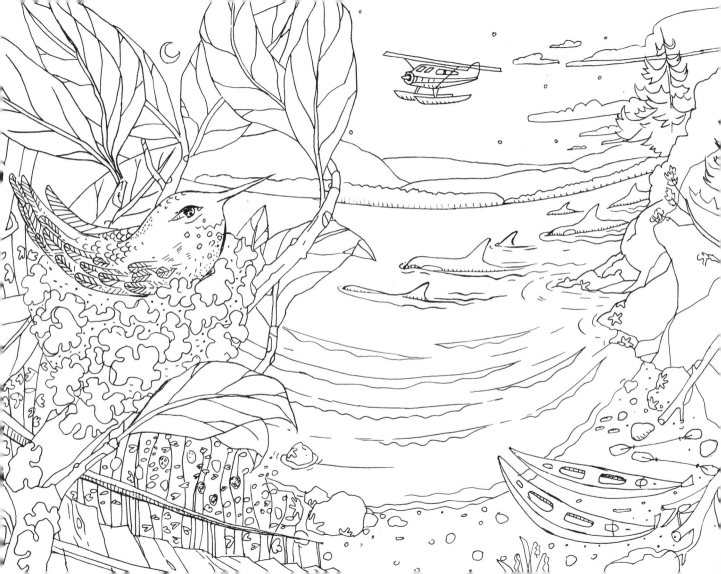

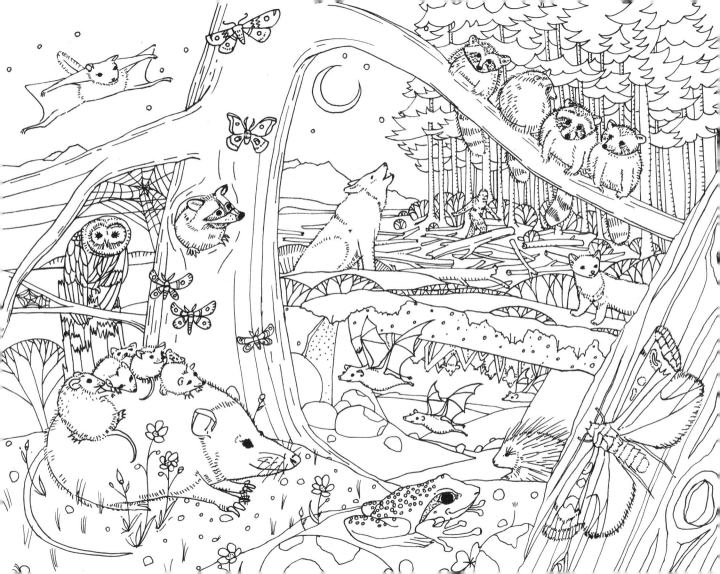

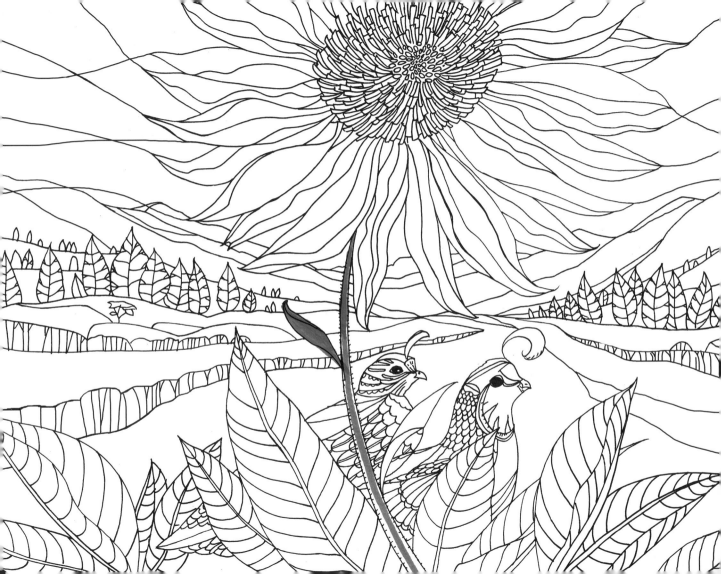

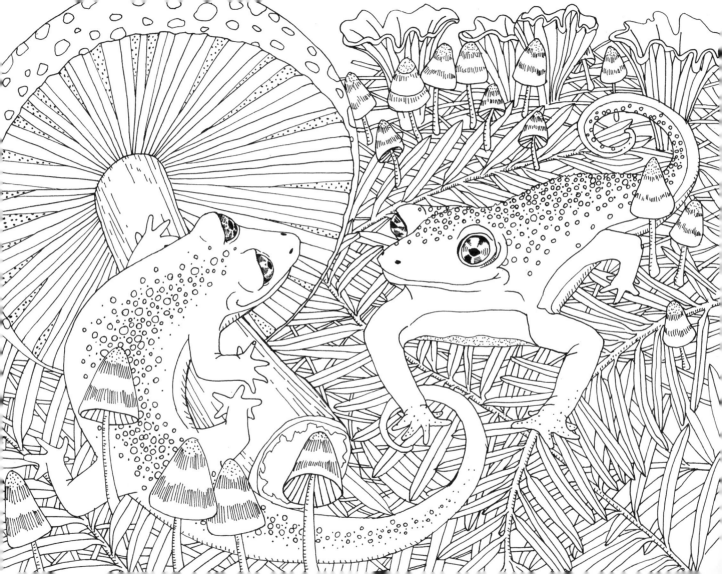

IDENTIFICATION GUIDE

These are the places, plants, animals, and more that inspired the art for *Pacific Northwest Nature*. Gray dots indicate labeled item.

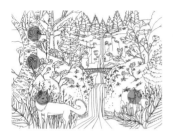

Multnomah Falls, Columbia River Gorge, Oregon
• Red fox • Black-tailed deer
• Downy woodpecker
• Pacific dogwood

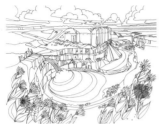

Dry Falls, Washington
• Arrowleaf balsamroot

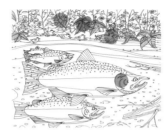

Elwha River, Olympic Peninsula, Washington
• Wood duck • Chinook salmon
• Sword fern • Bigleaf maple saplings

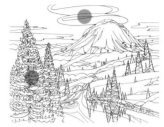

Mount Rainier, Washington
• Subalpine firs • Lenticular clouds

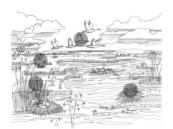

Willapa Bay, Washington
• Wood ducks • Canada geese
• Broad-leaved cattails
• Black-tailed deer

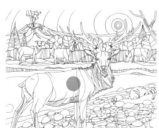

Toutle River, Mount St. Helens, Washington
• Roosevelt elk

Tide pools, Pacific coast
• Sea star • Dungeness crab • Blue mussel • Dall's acorn barnacles
• Salmon smolt

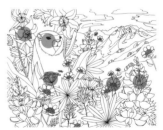

Midalpine meadow, Olympic National Park, Washington
• Olympic marmot • Lupine
• Feverfew • Avalanche lilies
• Cow parsnip

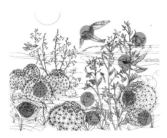

High desert, Eastern Washington
• Pincushion cactus • Pygmy rabbits
• Western rattlesnake • Scarlet gilia
• Western tiger swallowtail butterfly
• Burrowing owls • Bonneville
shooting star • Rufous hummingbird
• Common nighthawk

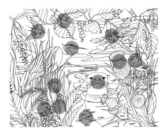

Nisqually River, Washington
• River otter • Dragonfly • Cliff swallow
• Skunk cabbage • Tadpoles • Canada
thistle • Great blue heron • Northern
red-legged frog • Black cottonwood
• Townsend's vole • American goldfinch

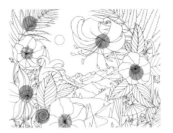

**Hurricane Ridge, Olympic National
Park, Washington**
• Nootka rose • Sword fern
• Avalanche lily • Tiger lily
• Bracken fern fiddleheads

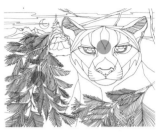

North Cascades, Washington
• Cougar • Douglas fir

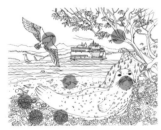

**Hood Canal and Olympic
Mountains, Washington**
• Pacific madrone • Harbor seal
• Sea stars • Anemones • Osprey
• Pacific rockweed • Western
sandpipers

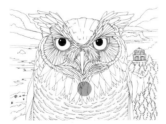

**Vista House, Columbia River
Gorge, Oregon**
• Great horned owl

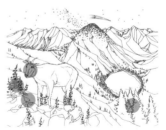

**Lake Ann, North Cascades,
Washington**
• Mountain goat • Fireweed
• Lichen • Pacific silver fir

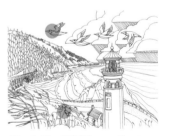

Heceta Head Lighthouse, Oregon
• Western gulls • Black-tailed deer

ABOUT SKIPSTONE

Skipstone is an imprint of Seattle-based nonprofit publisher Mountaineers Books. It features thematically related titles that promote a deeper connection to our natural world through sustainable practice and backyard activism. Our readers live smart, play well, and typically engage with the community around them. Skipstone guides explore healthy lifestyles and how an outdoor life relates to the well-being of our planet, as well as of our own neighborhoods. Sustainable foods and gardens; healthful living; realistic and doable conservation at home; modern aspirations for community—Skipstone tries to address such topics in ways that emphasize active living, local and grassroots practices, and a small footprint.

Our hope is that Skipstone books will inspire you to effect change without losing your sense of humor, to celebrate the freedom and generosity of a life outdoors, and to move forward with gentle leaps or breathtaking bounds.

All of our publications, as part of our 501(c)(3) nonprofit program, are made possible through the generosity of donors and through sales of more than 600 titles on outdoor recreation, sustainable lifestyle, and conservation. To donate, purchase books, or learn more, visit us online:

SKIPSTONE

LIVE LIFE

MAKE RIPPLES

www.skipstonebooks.org
www.mountaineersbooks.org

OTHER TITLES YOU MIGHT ENJOY

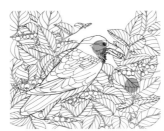

Coastal woodlands
• Common raven • Salal

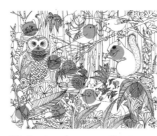

Wetland environment, Coast Range, Oregon
• Northern spotted owl • Pacific wren
• Common raccoon • Douglas' squirrel
• Golden chanterelles • Black bear
• Fisher • Banana slug • Foxglove
• Sulphur shelf fungus • Bracken fern fiddleheads • Sword fern

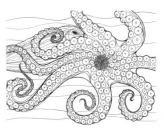

Puget Sound, Washington
• Giant Pacific octopus

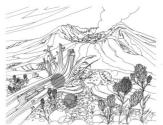

Mount St. Helens, Washington
• Douglas fir, downed log • Pumice
• Indian paintbrush

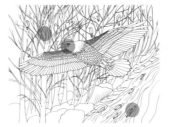

Skagit River, Washington
• Bald eagle • Salmon • Black cottonwood

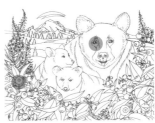

Mount Rainier, Washington
• Black bears • Cascades blueberries

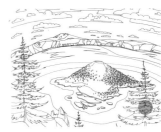

Crater Lake and Wizard Island
• Shasta red fir

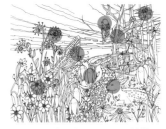

Ebey's National Preserve, Whidbey Island, Washington
• Black-tailed fawn • Bald eagle
• Chocolate lily • Woolly sunflower
• Bracken fern fiddlehead • Butterfly
• Douglas fir • Pacific rhododendron

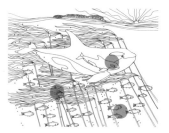

Puget Sound, Washington
• Orca • Bull kelp • Salmon

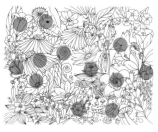

Mount Hood alpine meadow, Oregon
• Bunchberry • Avalanche lily
• Bracken fern fiddleheads • Harebell
• White mountain-heather • Blue
windflower • Subalpine buttercup
• Indian paintbrush • Cascade aster
• Banana slug • Steller's jay
• Golden-mantled ground squirrel

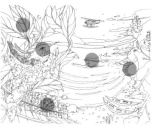

San Juan Island cove, Washington
• Orcas • Sea stars • Pacific madrone
• Rufous hummingbird
• Himalayan blackberries

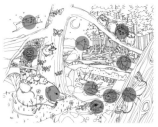

**Lowland forest, Cascade Range,
Washington and Oregon**
• Virginia opossum • Northern flying
squirrel • Ceanothus silkmoth
• Gray wolf • Common raccoons
• Little brown bats • Pacific chorus frog
• Long-tailed weasel • Common
porcupine • Barred owl

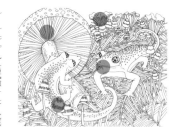

Methow Valley, Washington
• California quail • Arrowleaf
balsamroot

ABOUT THE ARTIST

Lida Enche lives in Seattle, Washington, where she loves teaching middle school art. She also enjoys painting, printmaking, and illustrating images that evoke the quiet and sometimes elusive beauty that surrounds us all. In her next life, she will be a professional beach bum who never has to apply sunscreen and a lavender farm owner, minus all of the hard work of actually owning a lavender farm.

**Cascade Range forest, Washington
and Oregon**
• Rough-skinned newt • Golden chan-
terelles • Prince mushrooms
• Fly amanita mushroom

Coastal woodlands
• Common raven • Salal

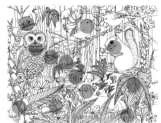

Wetland environment, Coast Range, Oregon
• Northern spotted owl • Pacific wren
• Common raccoon • Douglas' squirrel
• Golden chanterelles • Black bear
• Fisher • Banana slug • Foxglove
• Sulphur shelf fungus • Bracken fern fiddleheads • Sword fern

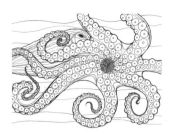

Puget Sound, Washington
• Giant Pacific octopus

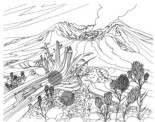

Mount St. Helens, Washington
• Douglas fir, downed log • Pumice
• Indian paintbrush

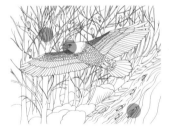

Skagit River, Washington
• Bald eagle • Salmon • Black cottonwood

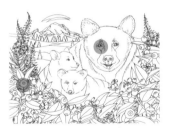

Mount Rainier, Washington
• Black bears • Cascades blueberries

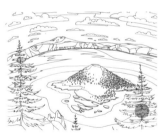

Crater Lake and Wizard Island
• Shasta red fir

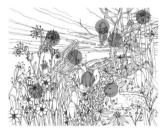

Ebey's National Preserve, Whidbey Island, Washington
• Black-tailed fawn • Bald eagle
• Chocolate lily • Woolly sunflower
• Bracken fern fiddlehead • Butterfly
• Douglas fir • Pacific rhododendron

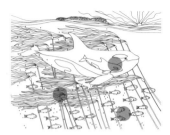

Puget Sound, Washington
• Orca • Bull kelp • Salmon

Mount Hood alpine meadow, Oregon
• Bunchberry • Avalanche lily
• Bracken fern fiddleheads • Harebell
• White mountain-heather • Blue
windflower • Subalpine buttercup
• Indian paintbrush • Cascade aster
• Banana slug • Steller's jay
• Golden-mantled ground squirrel

San Juan Island cove, Washington
• Orcas • Sea stars • Pacific madrone
• Rufous hummingbird
• Himalayan blackberries

**Lowland forest, Cascade Range,
Washington and Oregon**
• Virginia opossum • Northern flying
squirrel • Ceanothus silkmoth
• Gray wolf • Common raccoons
• Little brown bats • Pacific chorus frog
• Long-tailed weasel • Common
porcupine • Barred owl

Methow Valley, Washington
• California quail • Arrowleaf
balsamroot

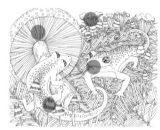

**Cascade Range forest, Washington
and Oregon**
• Rough-skinned newt • Golden chan-
terelles • Prince mushrooms
• Fly amanita mushroom

ABOUT THE ARTIST

Lida Enche lives in Seattle, Washington, where she loves teaching middle school art. She also enjoys painting, printmaking, and illustrating images that evoke the quiet and sometimes elusive beauty that surrounds us all. In her next life, she will be a professional beach bum who never has to apply sunscreen and a lavender farm owner, minus all of the hard work of actually owning a lavender farm.

ABOUT SKIPSTONE

Skipstone is an imprint of Seattle-based nonprofit publisher Mountaineers Books. It features thematically related titles that promote a deeper connection to our natural world through sustainable practice and backyard activism. Our readers live smart, play well, and typically engage with the community around them. Skipstone guides explore healthy lifestyles and how an outdoor life relates to the well-being of our planet, as well as of our own neighborhoods. Sustainable foods and gardens; healthful living; realistic and doable conservation at home; modern aspirations for community— Skipstone tries to address such topics in ways that emphasize active living, local and grassroots practices, and a small footprint.

Our hope is that Skipstone books will inspire you to effect change without losing your sense of humor, to celebrate the freedom and generosity of a life outdoors, and to move forward with gentle leaps or breathtaking bounds.

All of our publications, as part of our 501(c)(3) nonprofit program, are made possible through the generosity of donors and through sales of more than 600 titles on outdoor recreation, sustainable lifestyle, and conservation. To donate, purchase books, or learn more, visit us online:

www.skipstonebooks.org
www.mountaineersbooks.org

OTHER TITLES YOU MIGHT ENJOY